MW00907089

Dragon-maker's Handbook

By Dan Reeder

Watch the short companion
video at:

www.monster-man.com

Copyright 2009. Dan Reeder. All rights reserved.

Introduction

I've doing my own version of "papier mâché" for as long as I can remember. Okay, since 1972. That's actually about as far back as I can remember. When you get to be my age you'll understand.

Historically, the French version of papier mâché involved chewing or mashing paper, then squishing it into "art." There is nothing French or chewed about what has been passed off as papier mâché in the United States however. For that reason alone, I've decided to dispense with the French spelling and symbols. For most people in the United States, paper mache involved putting strips of newspaper into a paste, applying it to a balloon, watching it collapse, and then throwing it away.

More adept paper mache artists applied the newspaper strips over some kind of substructure like chicken wire. That is, they would sculpt with chicken wire and then apply a "skin" of paper mache. In contrast I sculpt with pieces of paper mache balls that I cut up and put together with masking tape. I then cover the sculpture with a skin of cloth dipped into white glue. This is a process I invented and dubbed "cloth mache" in my first book, The Simple Screamer: A Guide to the Art of Papier and Cloth Mâché (1984, Gibbs Smith Publishers, Layton, Utah). I also advise some critically different ways of making and applying the paste that will help you avoid the brittle and stinky pitfalls of traditional paper mache.

This Dragon-maker's Handbook is designed to guide you through the process of making a dragon like the one on the cover. It also parallels the short video on my website. If you get stuck, watch the video. If you are still stuck after that, contact me at dan@monster-man.com. I'll help you out as best I can.

This book will give you the basics of my non-traditional paper mache methods. However it is not intended to teach you everything I know about the subject. If that's what you want, then consider buying my new, very comprehensive book titled, Papier Mâché Monsters: Turning Trinkets and Trash into Magnificent Monstrosities (again, Gibbs Smith Publishers). This book will be available November 2009. Ask for it at your local bookstore. You can also find information about this book on my website.

I think this is a wonderful medium for artistic expression. I don't know any other medium so well suited for making large sculptures. Once you make a dragon, you will be hooked. No doubt you will want to make more projects after that. In fact, you might end up with every space in your house filled with strange creatures. Welcome to my world.

To my cat Eddy, although he doesn't care at all.

The complete list of what you need:

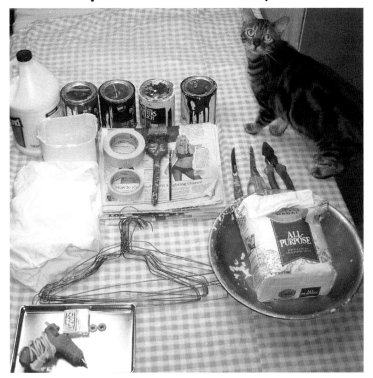

Stuff
- 8" stack of newspaper
- 1 roll wide, 1 roll thin masking tape
- Wire clothes hangers
- Cheap, white flour
- Fimo or Sculpy (oven bake clay)
- 1 old (old and worn as you can get) bed sheet
- 2 Quarts of white glue (safe, hobby type)
- Primary colors and black & white latex paint
- Anything round for the eyes: marbles, clay balls. For especially great eyes, use taxidermy eyes (pictured). You can get them on the web.

Tools
- Serrated knife (steak type knife, doesn't have to be sharp, just serrated)
- Scissors
- Wire cutters
- Bowls for paste and glue
- Baking sheet
- Hot glue gun
- 1 wide, 1 thin paint brush

- (optional) A little animal to get in your way.

For this body parts section you will need:

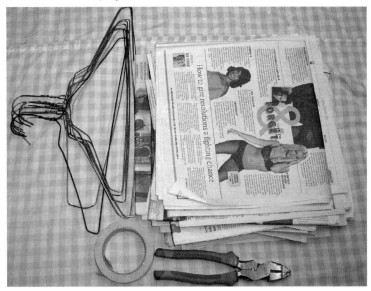

- Newspaper (quit staring)
- 1" tape
- Wire clothes hangers
- Wire cutters

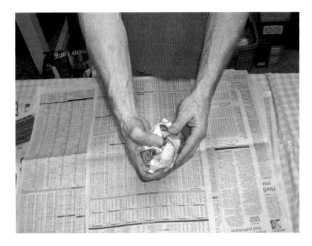

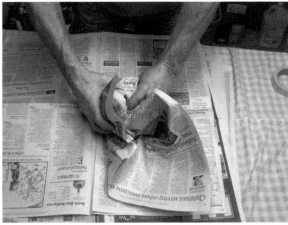

1. Unfold the paper. Crumple a ball.

2. Wrap the ball using successive layers…

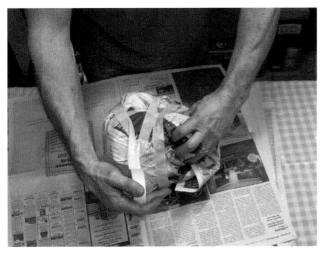

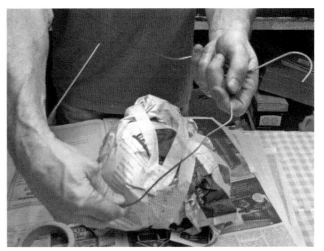

3. ...until it's "body" sized. Wrap with thin tape. Never use balloons here. Please. We don't want perfect symmetry. Keep this kind of loose. Let the dragon evolve.

4. Wire clothes hangers provide excellent body strength. Spread two wire hangers. Make them semi-round.

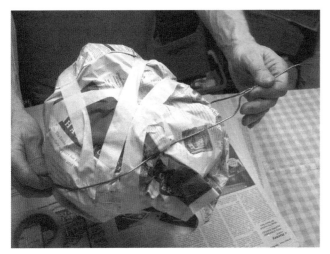

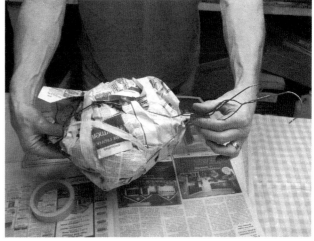

5. Stuff the body into one of the hangers. If you have excess wire, squeeze the wire together at the top. You can use this extra wire later to stick into the neck or the tail.

6. Put the second hanger around the ball (rotated 90 degrees). Wrap with tape again.

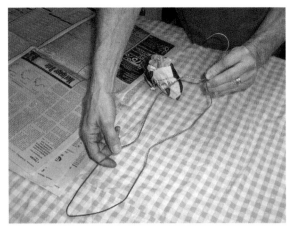

7. To make a leg, bend a hanger into a figure 8.

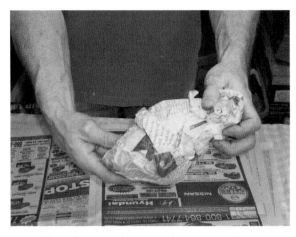

8. Crumple an elongated, "thigh" sized ball.

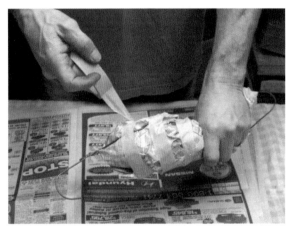

9. Stuff it into the upper half of the hanger. Wrap with tape.

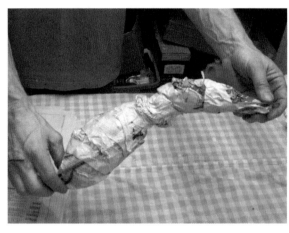

10. Put a "calf" sized ball into the bottom half of the hanger. Wrap with tape.

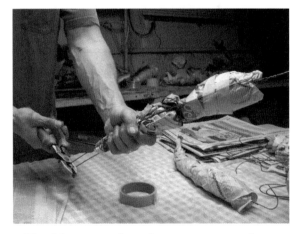

11. Use another hanger to make a tail. Clip the wire ends off so you that can make it pointed.

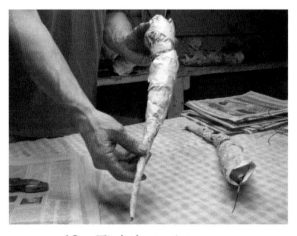

12. Tightly twist paper around the end and wrap it with tape.

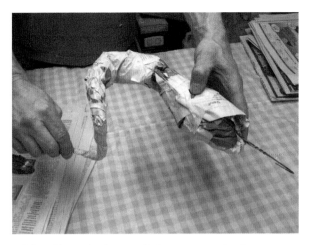

13. Bend the tail into a spiral.

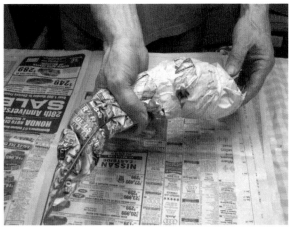

14. Make a "neck" in the same way you made a leg. In fact, the arms are made in the same way as the legs, just a bit smaller.

15. Crumple and tape a "head" sized ball, as well as 4 or 5 smaller balls to use for details later.

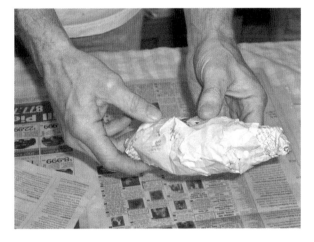

At this point you should have crumpled your body, two legs, two arms, a tail, a neck and a few smaller, extra balls. Gather these body parts for the paper mache stage.

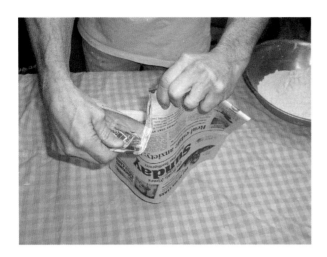
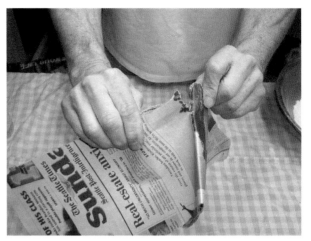

16. Time to paper mache. First tear some **LARGE** newspaper strips. No teeny weeny little strips here. Tear a section of newspaper in half.

17. Tear off the folded end. Then tear the section at the seam. This is the easiest way to get a pile of large, paper strips.

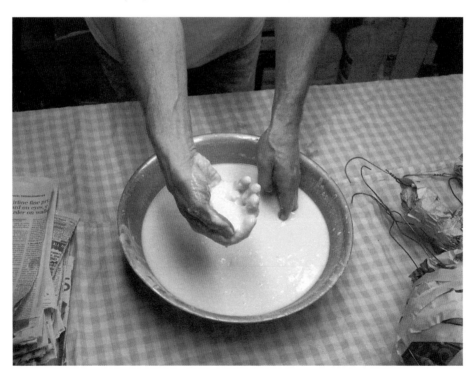

18. Pour white flower into a bowl. Add water and mix with your hands. Some paper mache "experts" will try to give you some perfect ratio of flour to water. Don't believe them. There is no perfect formula. Add water until it is the consistency of your favorite cream based soup. After you've worked for a while, you'll know whether to add more water or not. P.S. Warm water is nice (you deserve it).

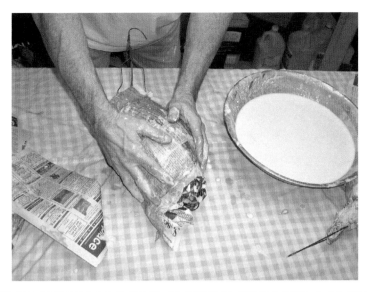

****19. THIS IS THE MOST IMPORTANT PAPER MACHE INSTRUCTION YOU WILL EVER GET.** Pay attention! Your third grade teacher taught you the wrong way. PUT ONLY YOUR <u>HANDS</u> INTO THE PASTE. <u>NOT</u> THE PAPER STRIPS! With <u>very wet hands</u>, put <u>one </u>strip of paper onto the ball at a time and smooth each strip until it is <u>thoroughly soaked</u>. My method insures that you don't get globs of paste or pockets of air in between paper layers which will weaken the ball and usually rot (and stink).

20. Work around the entire ball until you have 5 or 6 layers of paper.

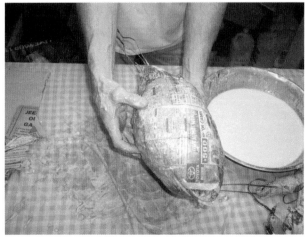

21. Hang up to dry. This is one of the nice features of having hangers inside the body. This will be surprisingly light and strong when dry.

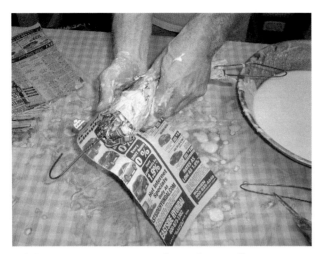

22. Keeping your <u>hands</u> really wet, start at the top of the leg …

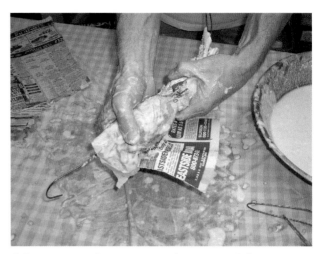

23. … and wrap with several layers of paper …

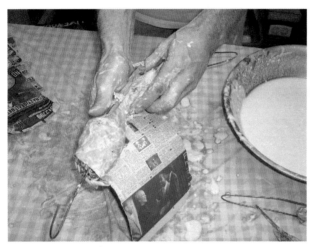

24. … as you work your way …

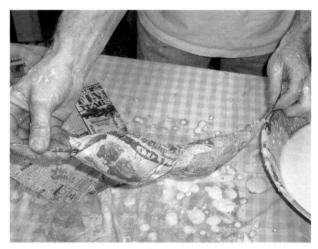

25. … to the bottom.

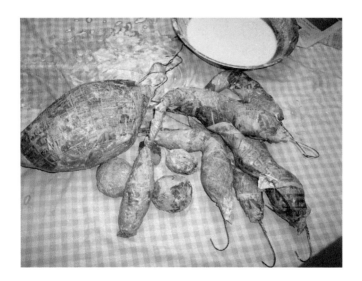

Mache all of your crumpled body parts. Hang them to dry someplace warm. It should take a couple of days. No, you can't rush this. No hair dryers. No ovens. No solar panels… well, that's not a bad idea.

For this fingers, toes, ear pieces, and tongue section you will need:

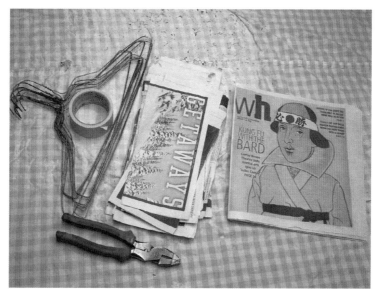

- Newspaper strips
- 1" tape
- More hangers
- Wire cutters

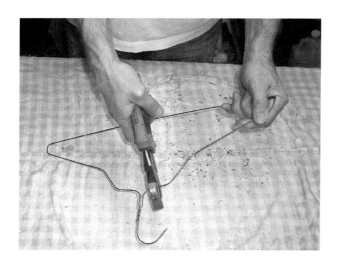

26. Putting hangers inside fingers and toes allows you to bend them into positions you like. Cut the hangers into various lengths.

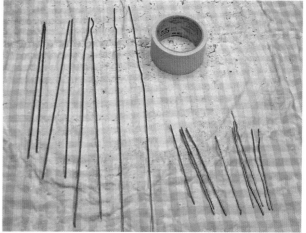

27. Cut eight long pieces (10 in. or so) for winged "fingers". Then cut eight shorter pieces (3 in.) for "toes". Now six even shorter pieces (2 in.) for the "ears". Cut two pieces for a tongue (not pictured, see p. 14).

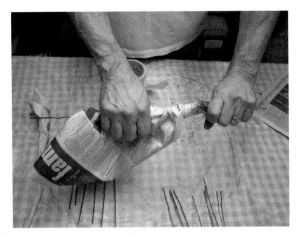

28. Wrap the paper tightly around the wire.

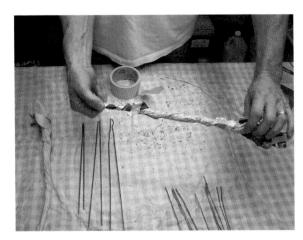

29. Twist and taper.

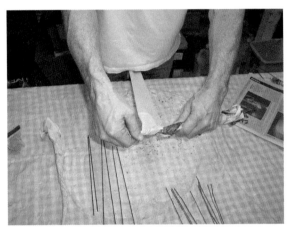

30. Put the tape between your legs. Keep the tape taut …

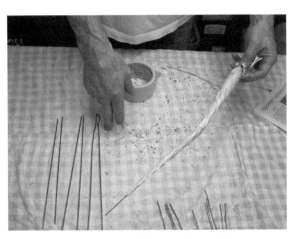

31. … and turn the "finger" pulling against the tape. Work from the tip to the base.

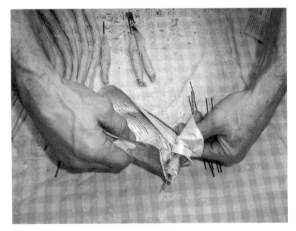

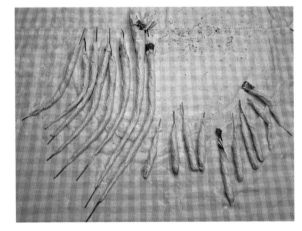

32. After you've made all the fingers do the same with the smaller, toe pieces although leave the ends more blunt. Taper the ear pieces as well (shown at the far right).

For the first "cloth mache" session you will need:

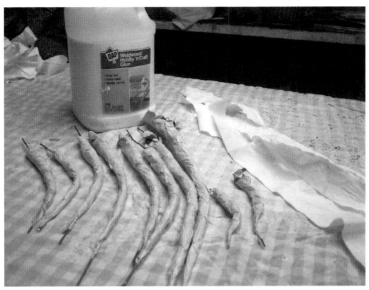

- White glue

- A section of the old bed sheet

- Your fingers and toes (no, the dragon's fingers and toes)

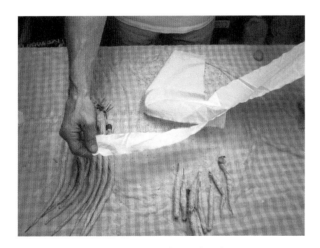

33. Tear the cloth into strips. These should be about an inch wide. Remove the annoying little strings.

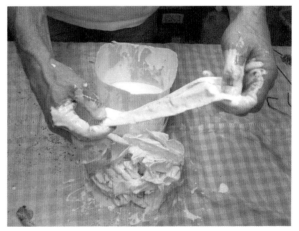

34. Dip a pile of these strips into the glue. (Yes, you may put your hands in the glue.) Get the strips thoroughly soaked with glue.

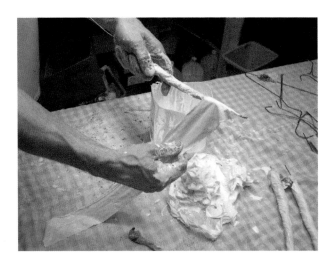

35. Start at the tip of the finger. Turn the finger keeping tension on the cloth strip.

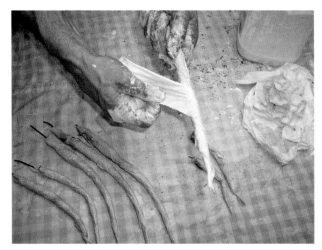

36. Work your way from pointed tip to the base using a single layer of cloth.

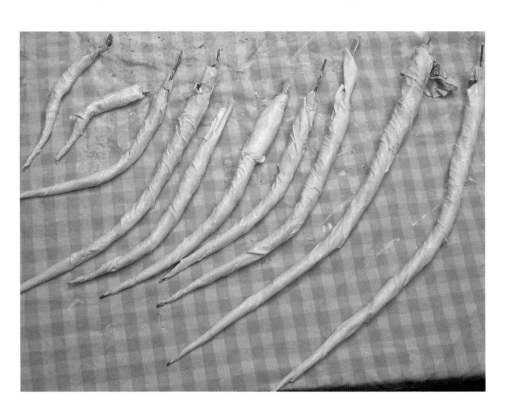

37. Put these someplace warm to dry. (I bend the hanger at the end with wire cutters and hang them so that they don't stick to the table.)

For the teeth, claws, and horns section you will need:

- Some type of "oven bake" clay (Ask at any craft store. I'm using "Super Sculpey" here, but I like "Fimo" as well.)
- A Baking sheet

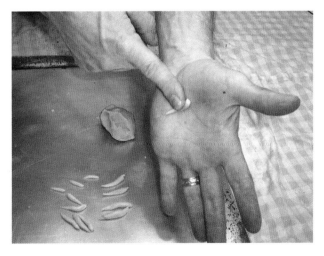

38. Roll the clay on your palm or between your fingers to make a point. Bend them slightly.

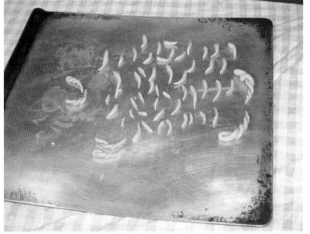

39. Make a pile of these of various sizes. These will be your teeth, claws, and possibly horns. Cook them in the oven according to the directions. Now you are ready to assemble the jaws.

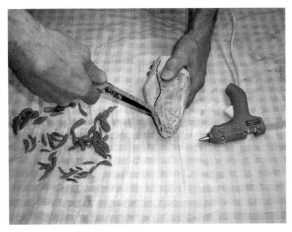

40. Use your serrated knife to cut your head in half.

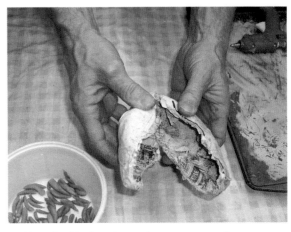

41. Pull the head apart and take out the crumpled paper.

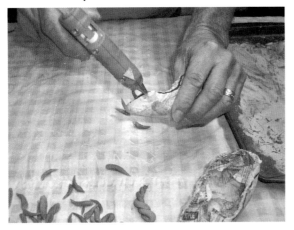

42. Use hot glue to attach rows of teeth.

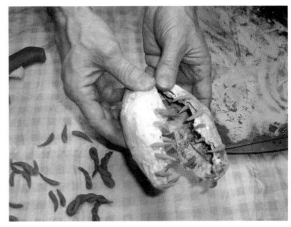

43. Rough jaws.

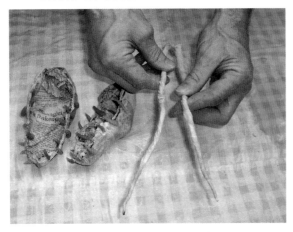

44. Make two more long, very thin toe type pieces of wire and twisted paper.

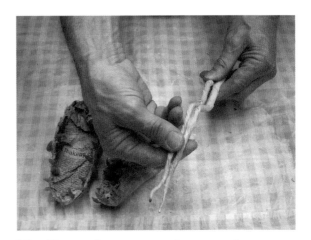

45. Tape them together on the underside to make a tongue. Put ripples in it. Leave a fork at the end.

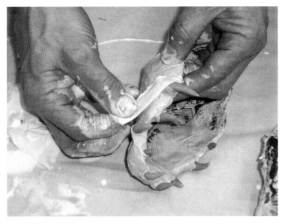

46. Time for another short glue and cloth session. Dip a small strip of cloth into glue. Fold it lengthwise.

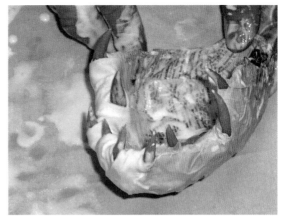

47. Wrap each tooth to secure it to the jaw.

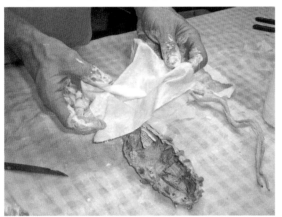

48. Cut a square piece of cloth a little larger than the jaw.

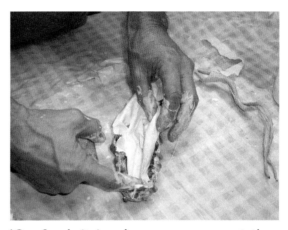

49. Soak it in glue, squeeze out the excess, and lay it into the jaw. Leave the wrinkles (of course).

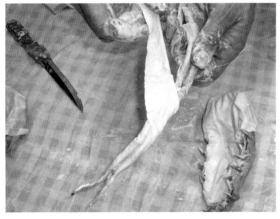

50. Wrap the tongue with a wide strip of wet cloth.

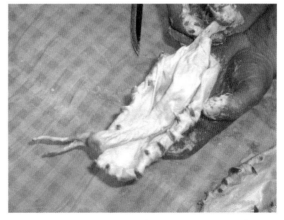

51. Lay it into the lower jaw. Put cloth into the upper jaw as well. Let these jaws dry overnight.

For the first paint session you will need:

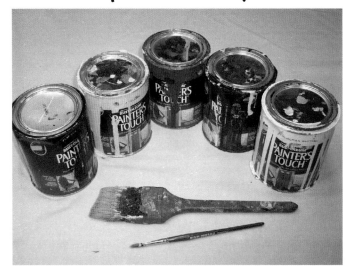

- Some latex paint

- 1 wide brush, 1 thin brush

Note: You can buy quarts of latex paint very close to primary colors at home improvement stores. Get red, blue, yellow, black, and white. You can paint the jaws at a later stage if you want. But it is much easier to do it now, while they are apart. More on painting later.

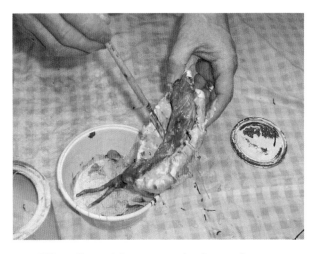

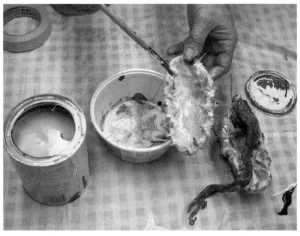

52. Consider any dark and complementary light color. Paint the tongue first with the dark color. While it's <u>still wet</u>, slap on the lighter color everywhere else.

53. Blend where the two colors meet, but <u>don't</u> make it too homogeneous. It looks better if it's left a bit uneven. Use a little dark and mostly light color for the upper jaw.

For the assembly section you will need:

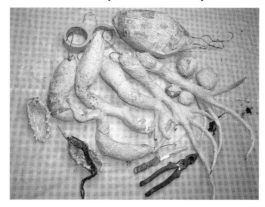

- All your body parts
- Knife and wire cutters
- Masking Tape

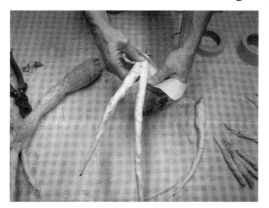

54. Tape two of the wing "fingers" together using your wide masking tape.

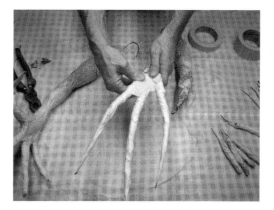

55. Add another.

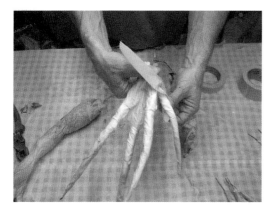

56. And the last.

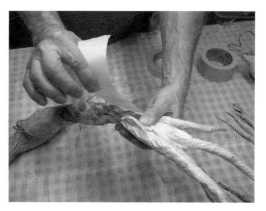

57. Cut off the extra wire at the end of the arm, but leave enough to push into the hand (for a strong wrist). Tape.

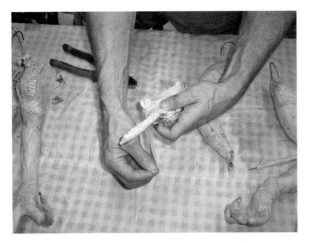

58. Follow the same procedure for each foot.

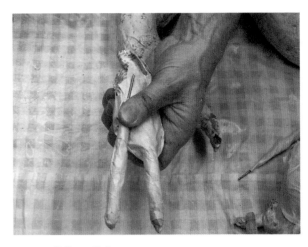

59. Of course you are using your toes.

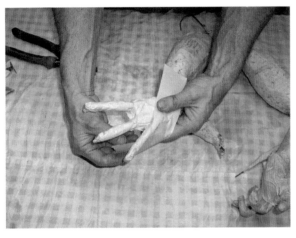

60. Tape.

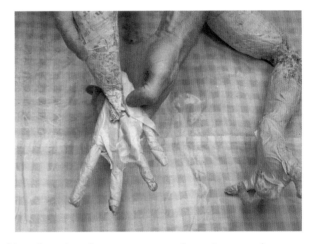

61. Again, leave enough wire at the end of the leg to make a strong ankle.

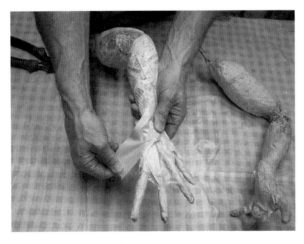

62. Tape.

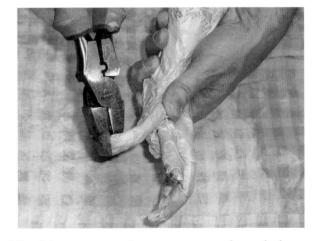

63. Use your wire cutters to bend the toes if you want.

18

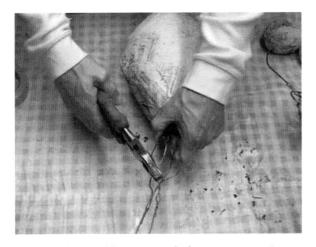

64. Cut off most of the extra wire ends as you use each body part.

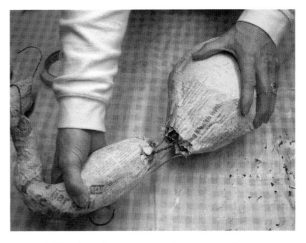

65. Push the neck onto the exposed wire stubs...

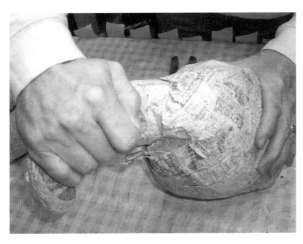

66. ...until the neck is inside the body.

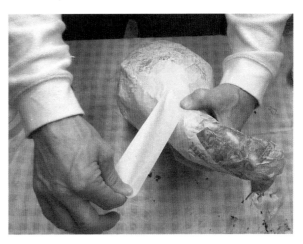

67. Tape Liberally.

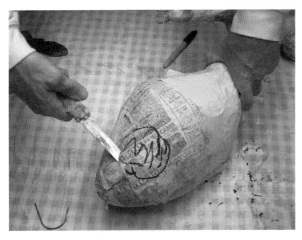

68. Cut a hole for a leg. Ideally, the hole should be a little smaller than the leg...

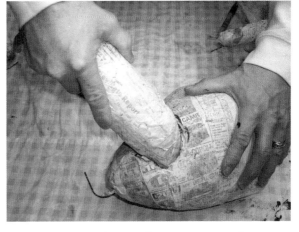

69. ...so that when you push in the leg it will be snug. Tape.

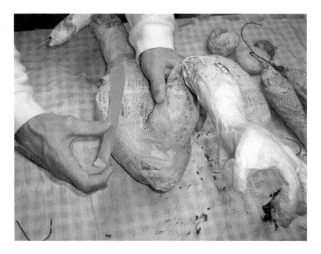

70. And tape some more.

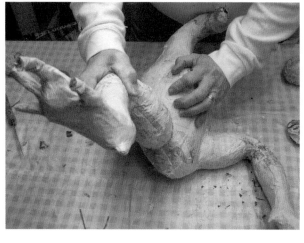

71. Do the same with the other leg.

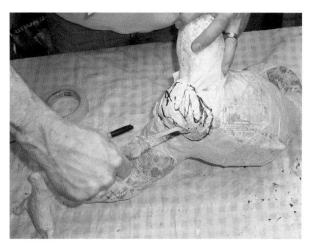

72. Cut a hole for the tail.

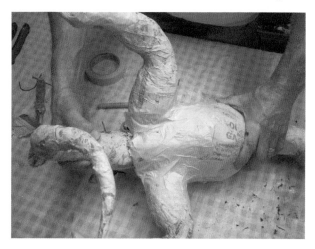

73. Push the tail inside the body.

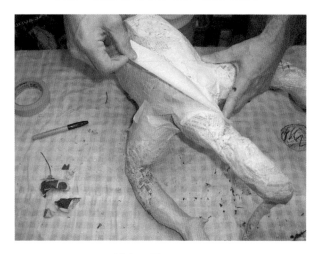

74. Tape.

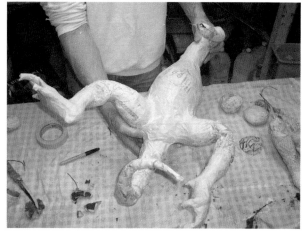

Looks like a chicken...sort of.

You must admit, this is getting fun.

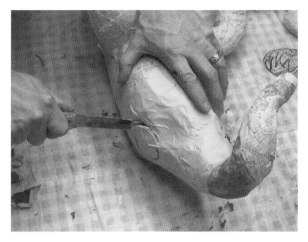

75. Cut an arm hole.

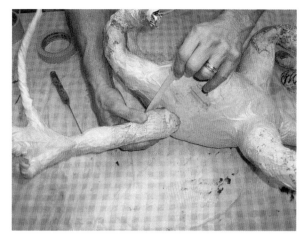

76. Cut off the end of the hanger and stuff the arm into the hole. Tape.

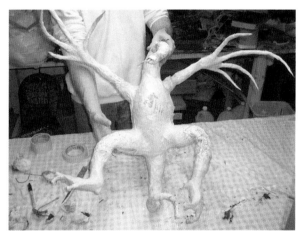

77. Do the same with the other arm.

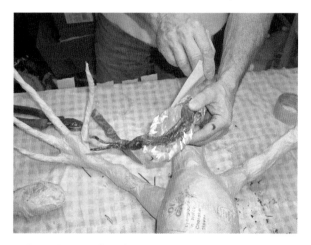

78. Tape the lower jaw to the neck.

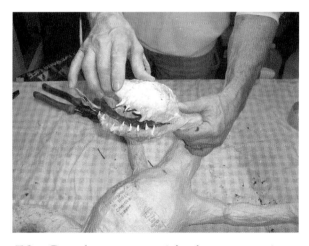

79. Do the same with the upper jaw.

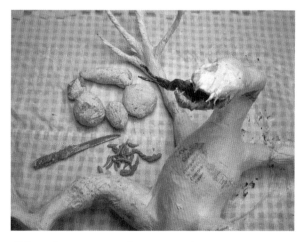

80. Get your claws and some extra balls for the next step.

81. Hold the claw against the toe.

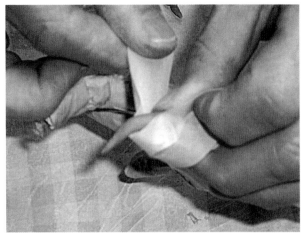

82. Wrap the tape around both.

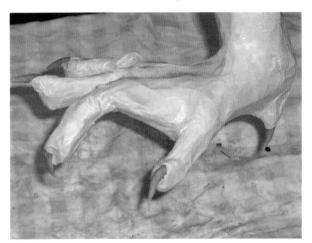

83. Continue around the foot.

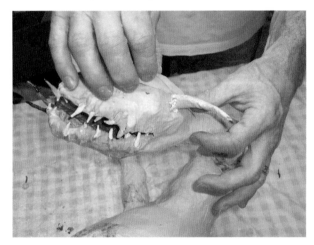

84. Poke your ear pieces into the side of the head. Add tape.

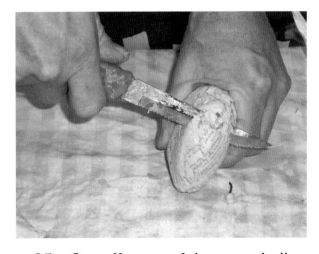

85. Cut off parts of the extra balls…

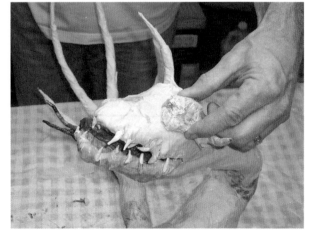

86. …to embellish the head.

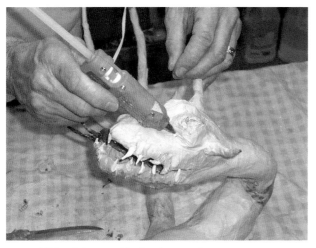

87. Use a little hot glue ...

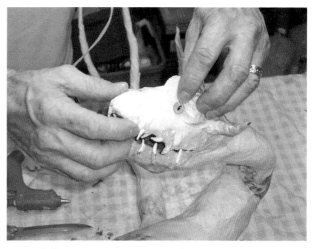

88. ... to put on the eyes.

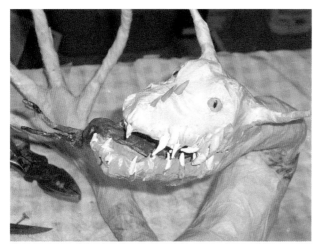

89. If you want, add a few horns to the top of the nose.

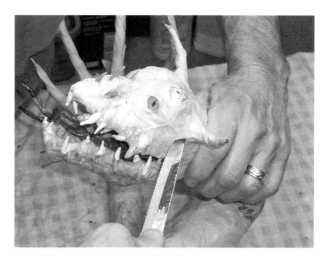

90. Punch ear holes into the sides of the head.

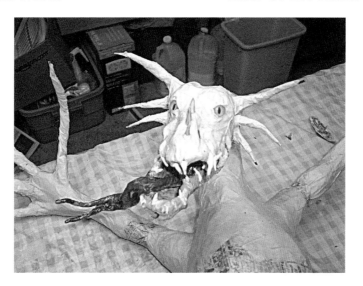

91. Add the rest of the tapered ear pieces. It is starting to look alive. (Don't leave it alone with the baby.)

This is the place to add a few more embellishments. Use some of the extra mache balls to make muscles and kneecaps. Having wire hangers inside the legs and the arms will let you bend them any way you wish. Try out various positions. You will know when the positions are "right". The dragon will take on a unique personality. Have some fun here. Well, keep your clothes on, but enjoy yourself.

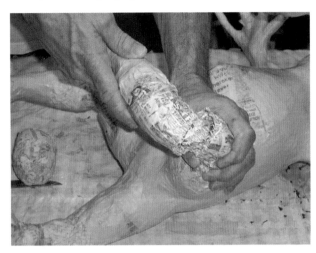

92. Break the legs and arms at the knees and elbows. Bend them to fit your dragon's personality. Tape.

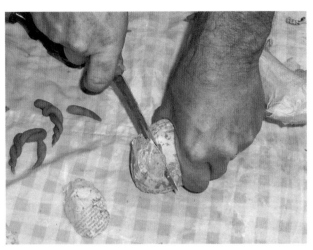

93. Cut pieces of the extra mache balls to add muscles, or just lumps.

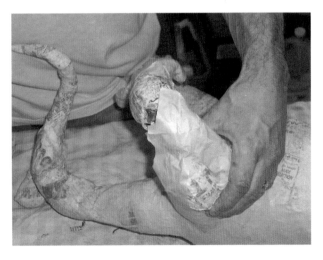

94. Add thigh muscles.

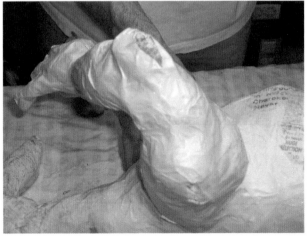

95. Secure with plenty of tape. Use another mache piece for a kneecap.

For the second cloth session you will need:

- White glue

- Plenty of different sized pieces of cloth

Note: It's best to have these pieces cut and ready before you stick your hands into the glue. To make these pieces, tear your cloth into strips of various widths. Then fold them, pull off the little strings, and cut them at the folds.

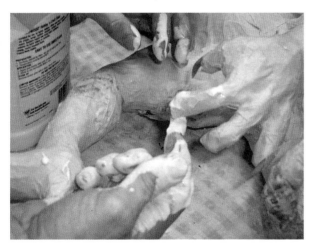

96. Start at the tip of the toe. Wrap small strips of wet cloth around each claw.

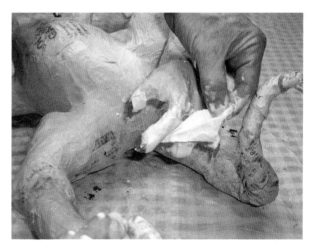

97. Wrap larger strips around the toes.

98. For some detail, use a piece of cloth large enough to add some folds. These make great wrinkles in places where a dragon should have wrinkles…

99. …like knuckles and ankles.

100. Using various sized pieces of cloth, cover the foot.

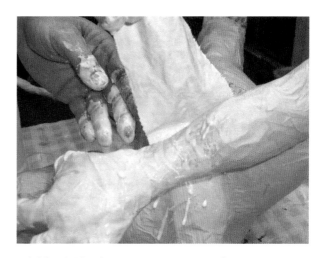

101. Work your way up the leg.

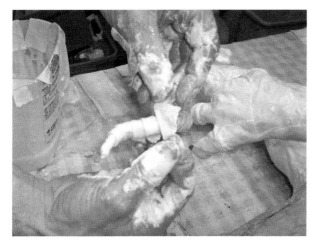

102. After finishing both legs, begin some breast plates at the tip of the tail. Fold each strip ...

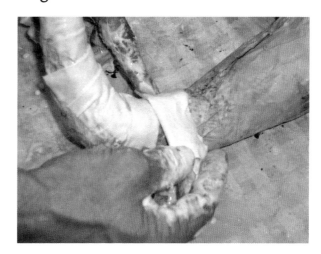

103. ... for added thickness. Apply each strip on top of the previous one working your way up the tail ...

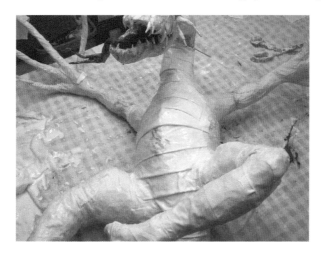

104. ... the stomach, up the neck, all the way under the jaws.

27

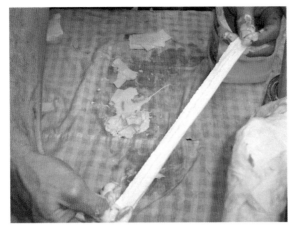

105. Soak in glue a cloth strip a bit longer than the length of the lower lip.

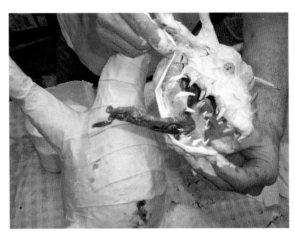

106. Fold it lengthwise for thickness and wrap around the lower jaw.

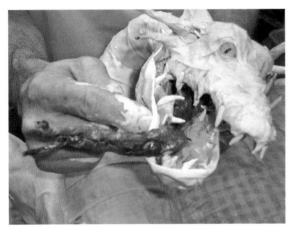

107. Press the cloth against the jaw, but leave some curves.

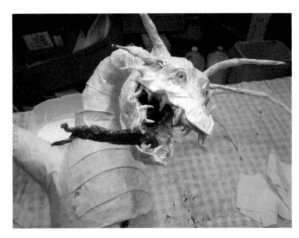

108. Repeat the process for the upper jaw.

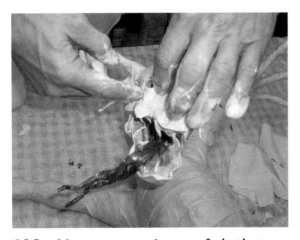

109. Use square pieces of cloth to wrap under and over the eyes.

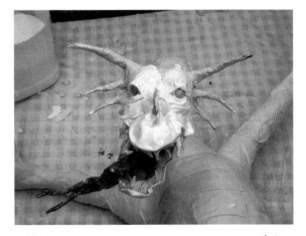

110. Any time you wrap something square around something round, wrinkles form. Perfect.

28

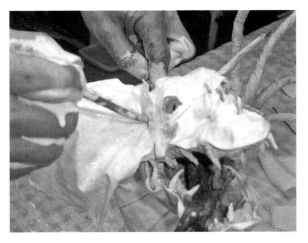

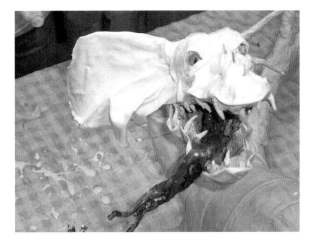

111. Wet a large piece of cloth. Poke it into the ear hole with a pencil.

112. Drape the rest of the cloth over the ear pieces. Wrap the excess around to the back of the ear.

113. You might want to push the cloth deeper between the pieces of the ear (a matter of taste). Do the same with the second ear. Leave the back side of the head to finish later.

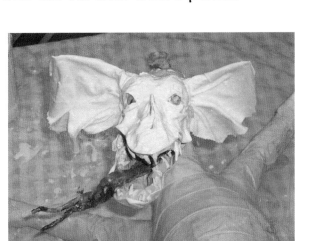

114. Since you will drape the wings much like the ears, prop the dragon upside down.

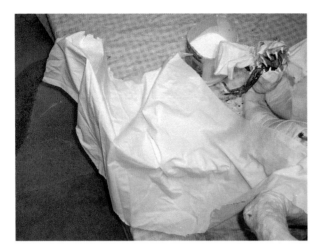

115. Like with the ear, cut a piece of cloth bigger than the wing.

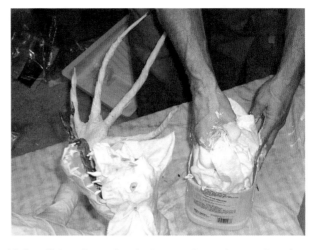

116. Dip the cloth into the glue. Soak completely and squeeze out the excess.

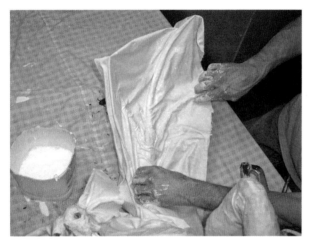

117. Drape over the wing. Push the cloth between the "fingers."

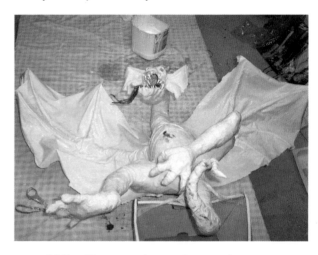

118. Drape the other wing.

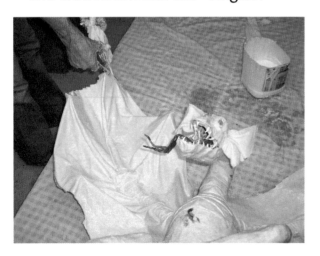

119. Because of the weight, you might need to loosely trim some of the excess cloth while it's still wet. Let the wings dry overnight.

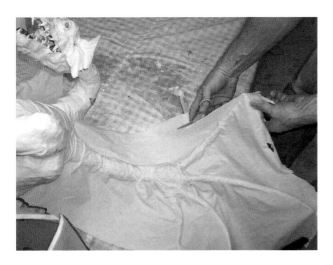

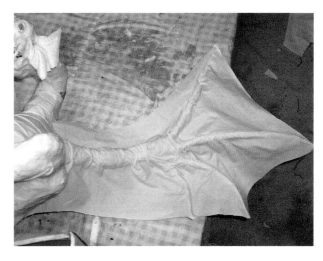

120. After they are dry, use scissors to shape the wings.

121. Cut curves between the fingers.

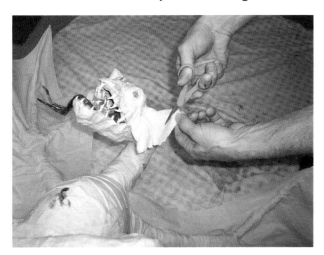

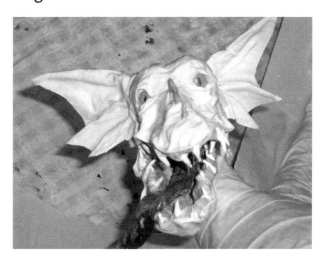

122. Cut a similar pattern into the ears. Turn the dragon over and use cloth strips to cover the backsides of the fingers and the pieces behind the ears.

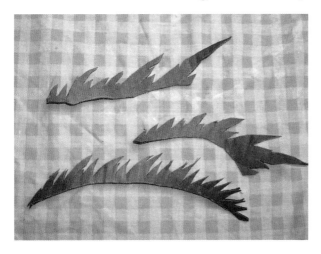

123. If you want to add a "spine" down the neck and back, start by cutting some cardboard. Simple triangle shapes will do, but you can make them as elaborate as you want.

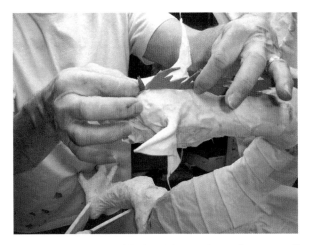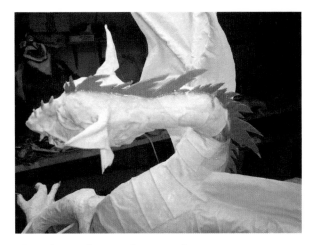

124. Hot glue the cardboard spine along the neck.

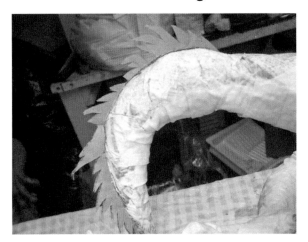

125. And down the tail.

126. Cover the cardboard spine completely with small pieces of cloth.

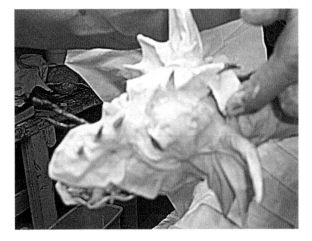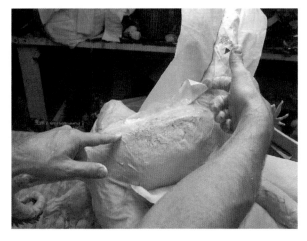

127. Finish clothing the head by adding small pieces of cloth any place that is uncovered. Use various sized pieces of cloth to work your way down the back. Cover the crease between the wings and the body.

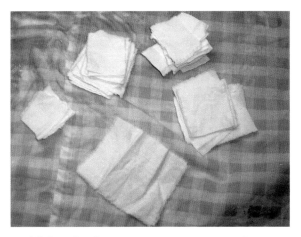

128. Scales are just square pieces of cloth …

129. … dipped into glue and folded to a point.

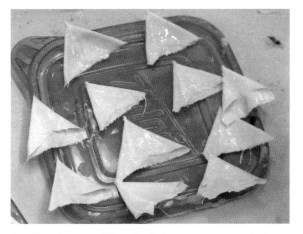

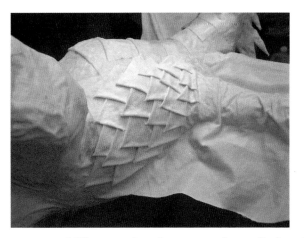

130. Layer like bricks. Start with a row, then another, placing the new points between the previous ones. Apply <u>patches</u> of scales wherever they fit …

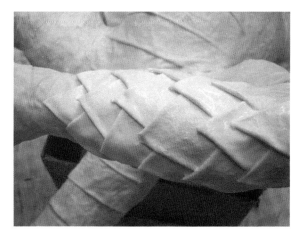

131. … the face, neck, tail, body, shins, and calves. Trust me, you don't need to cover the entire dragon to have it look great.

For the second painting session you will need:

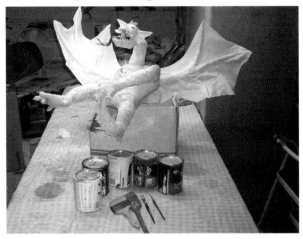

- Your latex paints
- One large brush (1"-1½")
- One small brush for details

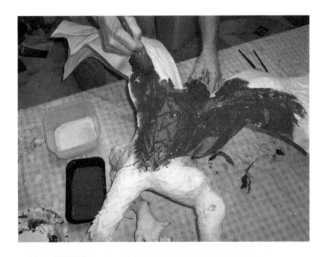

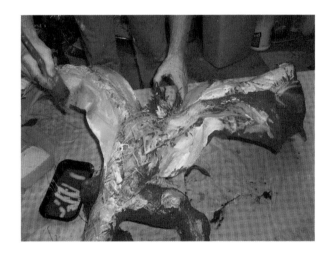

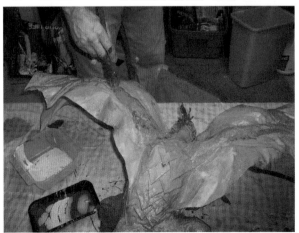

132. Start on the back. Use a dark color. Apply a generous amount of paint. While this is <u>still wet</u>, apply a lighter color. Blend, but leave the color unevenly distributed.

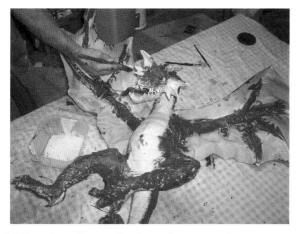

133. Apply a dark color on the arms.

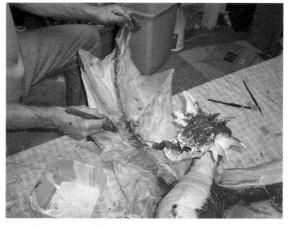

134. A light color on the wings.

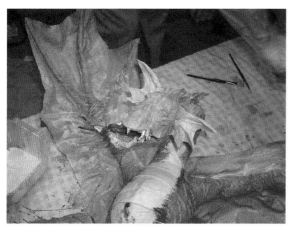

135. While it's all still wet, blend the two colors where they meet.

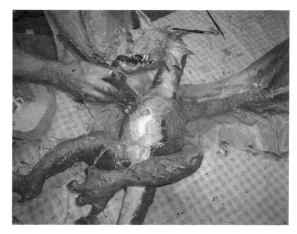

136. Choose another slightly different color (or just add some white) to the underbelly.

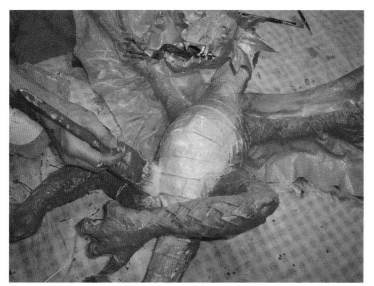

137. Paint the underbelly all the way from the tip of the tail to under the chin. Again, blend the colors where they meet. Allow this to dry overnight before the next stage (which I call "blackwashing").

For Blackwashing you will need:

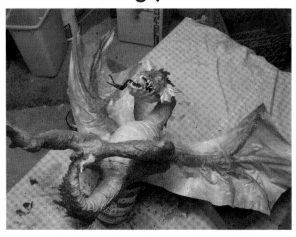

- Some black latex paint

- Brushes

- A slightly wet rag.

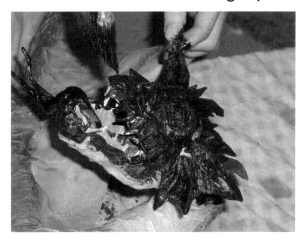
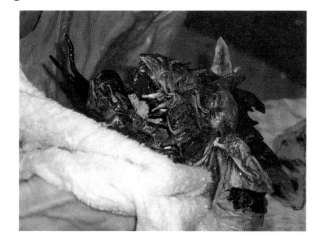

138. Dilute the black paint with a <u>little</u> water. Paint the face, then wipe it off before it dries. Blackwash inside the mouth using your small brush.

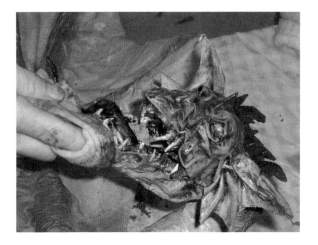
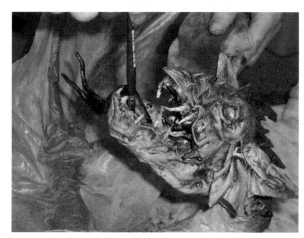

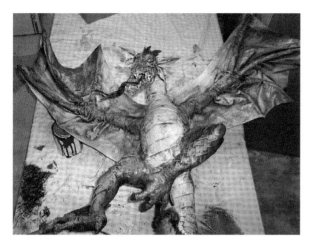

139. Some of the black will dry before you can wipe it off.

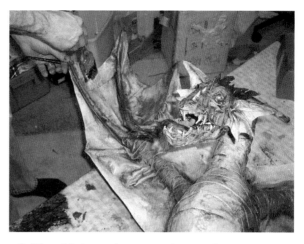

140. Using the regular colors sparingly, add back some highlights.

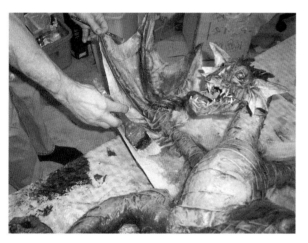

141. Light colors on the wings.

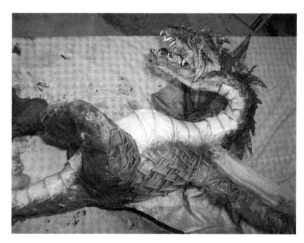

142. A little darker on the scales.

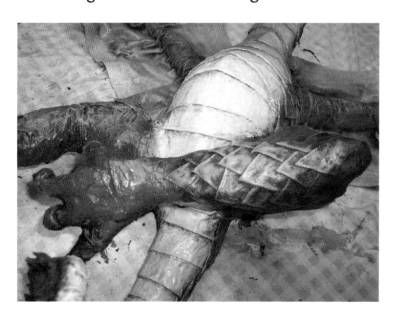

143. Add these highlights wherever the black got too pronounced. Or be brave and splash on some completely new colors for highlights.

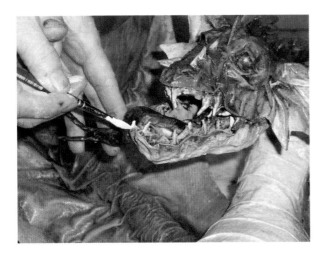

144. Paint the teeth.

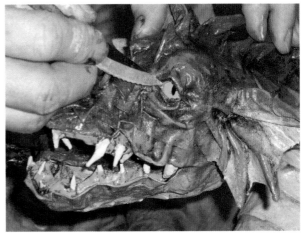

145. If you used glass eyes, scrape the paint off.
Otherwise, paint the eyes.

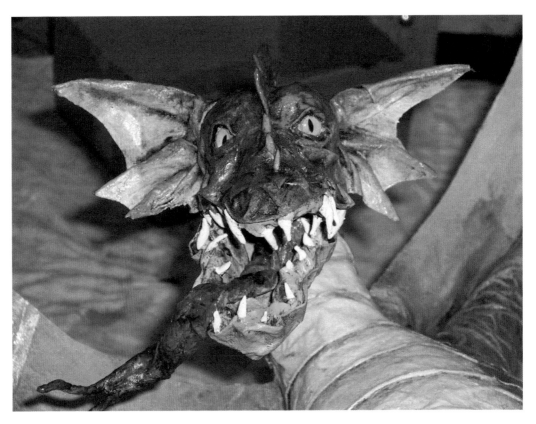

Notice that your dragon has come alive.

CONGRATULATIONS!

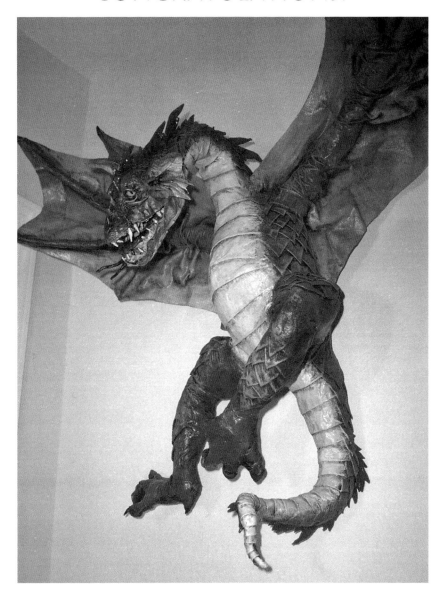

146. If you want to hang your dragon on the wall, use an ice pick or a nail to punch a hole in the back. Put a long screw or nail in the wall (try to hit a stud). Hang the dragon on the screw. Or, just strap your dragon to the front of your truck. Trust me, people will get out of your way!

I hope you enjoyed yourself. Thanks for making art.

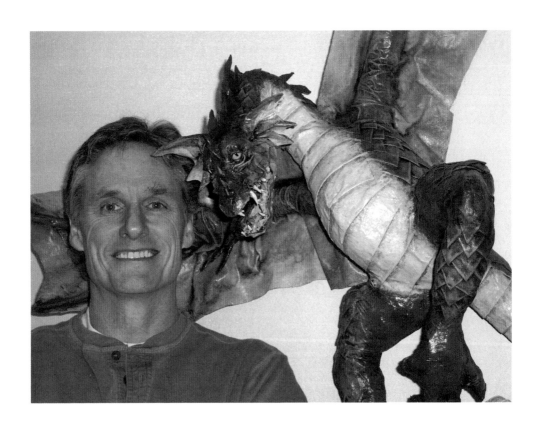

The Author

I'm a paper mâché artist who lives in Seattle, Washington. My other books include, *The Simple Screamer: A Guide to the Art of Papier and Cloth Mâché (1984)*, *Make Something Ugly for a Change: The Definitive Guide to Papier and Cloth Mâché (1999)*, *Papier Mâché Monsters: Turning Trinkets and Trash into Magnificent Monstrosities (2009)*, Gibbs-Smith Publishers, Layton, Utah.

Finish a dragon? Email me a picture. Give me permission to put it on my site, with your name under it of course.

10184871R00025

Made in the USA
Charleston, SC
14 November 2011